New Work on Paper 3

Bernice Rose
The Museum of Modern Art
New York

The exhibition *New Work on Paper 3* has been
organized with the aid of grants from R. L. B.
Tobin and the National Endowment for the
Arts. This publication is made possible by a
generous grant from Asher Edelman.

Design by Richard Simon Haymes
Production by Dale Cotton
Typeset by U.S. Lithograph Inc.
Printed and bound by Schneidereith & Sons

The Museum of Modern Art
11 West 53 Street
New York, New York 10019

Printed in the United States of America

Contents

Preface and Acknowledgments 5

Introduction 7

Robert Morris

Bruce Nauman

James Rosenquist

Robert Ryman

Pat Steir

Robert Wilson

Preface and Acknowledgments

This is the third in a series of exhibitions organized by The Museum of Modern Art, each of which is intended to show a relatively small number of artists through a representative selection of their recent drawings. Emphasis is placed on new work, with occasional glances backward to earlier production where the character of the new art especially requires it, and on artists or kinds of art not seen in depth at the Museum before. Beyond this, no restrictions are imposed on the series, which may include exhibitions devoted to heterogeneous or compatible groups of artists, and works of art ranging from traditional drawing to work on paper in mediums of all kinds. Without exception, however, the artists included in each exhibition are presented not as a definitive choice of outstanding contemporary talents, but as a choice, limited by the necessities of space, of only a few of those whose achievement might warrant their inclusion—a choice, moreover, that is entirely the responsibility of the director of the exhibition.

The exhibition departs from the format of works on paper only to include drawings on other supports, while the catalog, written and designed in advance of the final exhibition selection, gives an idea of each artist's work appropriate to the catalog format.

The New Work on Paper series, as with any exhibition, has been made possible through the cooperative efforts of many people, and this show is no exception. Once again, The Museum of Modern Art has been fortunate in having had the artists participate in this endeavor, and particularly in the publication. I would like to thank Bruce Nauman, James Rosenquist, Robert Ryman, Pat Steir, and Robert Wilson for creating original works specially for reproduction in this catalog, and to thank Robert Morris as well as Rosenquist, Ryman, Steir, and Wilson for creating works specially for the exhibition. Many people associated with the artists have been helpful, including, as ever, collectors of their work. I would especially like to thank Mr. Martin Visser of Bergejk, the Netherlands, and Rudi W. D. Oxenaar and Toos van Kooten of the Kröller-Müller Museum in Otterlo, the Netherlands, for their continuing generosity to the Museum and, particularly, for lending drawings by Nauman.

The following individuals and galleries have been of assistance throughout: For Bruce Nauman, Angela Westwater, Sperone Westwater, New York; Konrad Fischer, Konrad Fischer Gallery, Cologne; and Leo Castelli and Patty Brundage, Leo Castelli Gallery, New York. For Robert Morris, Ileana Sonnabend and Antonio Homem, Ileana Sonnabend Gallery, New York; and Leo Castelli, Leo Castelli Gallery, New York. For Robert Ryman, Daryl Y. Harnisch, Galerie Maeght Lelong, New York. For Pat Steir, the artist. For Robert Wilson,

the Paula Cooper Gallery, New York; and Ronald Vance, Byrd Hoffman Foundation, New York.

Many colleagues have been most generous with support and advice. At the Museum Riva Castleman and John Elderfield have been especially helpful. Susan Mason, Curatorial Assistant in the Department of Drawings, has been a very able and amiable coordinator of all aspects of the exhibition and the publication, for which she compiled the artists' biographies. Antoinette King, Director of Conservation, and Ann Craddock, Assistant Conservator, have again been invaluable in dealing with conservation and special installation problems. Kate Keller worked with extraordinary skill and patience to solve the problems of photographing the work of Ryman and Morris. Pamela Lewis was most diligent in attending to the numerous details of correspondence and organization. I am particularly indebted to Jerry Neuner, Production Manager, for his coordination and supervision of all aspects of the installation. Richard Simon Haymes has provided an inventive design for the catalog. Harriet Schoenholz Bee has, as always, been the most helpful of editors.

The Museum of Modern Art is grateful for generous support from R. L. B. Tobin and from the National Endowment for the Arts, which made this exhibition possible. Finally, on behalf of the Museum, I wish to thank Asher Edelman for his generous support; without his help this publication would not have been possible.

Bernice Rose
Curator
Department of Drawings

Introduction

Much of the most serious and original art of the recent past can be classified as drawing. Drawing has been chosen by contemporary artists as an alternative medium and has taken its place along with painting and sculpture as a major expressive voice. It is an inextricable part of recent painting, while continuing to be the primary study means for painting and sculpture as well as architecture. Drawing permits the artist to practice the most sensuous and rigorous aspects of representation and to explore particular systems for the construction of illusion. And, like poetry, it can offer the artist the chance to construct a supplementary or alternative model free from the rules that govern work in other mediums.

Until the end of the nineteenth century drawing had been the principal structural agent of representation in a system in which art's primary task was to imitate external reality. But since the nineteenth century the opposite has been true: drawing, painting, and sculpture (and various new mixed modes) have taught us that the artist's world is about the possession of reality through vision itself and about the objectification of internal necessity. The primary task of modern art has been to construct a reality that belongs to works of art alone, one that is sometimes independent of, but is always more important than, anything represented.

In twentieth-century art the space ''behind'' the picture's surface, where figures and objects used to live in an orderly manner, began to press forward, compressing and displacing them onto the surface itself. It then expelled them, expanding outward to encompass the spectator's own space, at first slowly and then, within the past twenty years, very rapidly. As this happened a vacuum was created; while new things rushed in to fill it, space itself also became a subject of art.

In this situation the problem of representation became a lively artistic game. The threatened disappearance of man from the picture turned into a game of hide-and-seek in which the figure is sometimes present and sometimes displaced to play the role of spectator. An important aspect of some recent art is that a phenomenological space, one of sensation, has become integral to it: the viewer discovers that he or she has become both the object and the subject of the work.

New Work on Paper 3 is ultimately about diversity. It is about many possibilities that exist under the one covering term *drawing*. But today drawing is not a term that denotes a unified set of rules any more than it is a way of going about creating a structure that projects a rationalist view of the world or a vehicle for expression within a structure of completely realized and self-explanatory forms. Drawing, relieved of its role as the

primary agent of imitation, offers the artist a new freedom of organizational methods, an extraordinary flexibility of sources, materials, and techniques. Along with the traditional rapid stop and go, there is an even greater freedom to rearrange, select, fragment, add on, displace, replace, repeat, vary, multiply, delete, cut, scrub, pose, juxtapose, suggest, present, and even represent. There is also a changed focus on line as an agent of illusion; line, like paint, has had to speak for itself, to *evoke* life, not just describe it. Yet, drawing has remained what it always was, a mode of thinking new thoughts.

The drawings in this exhibition are by artists who belong to more than one artistic generation, each of which has been characterized by a particular revolutionary attitude toward drawing. While concerns are shared, and issues relevant to one are relevant to others, their expression is wholly individual. For the fortunate—or the strong—time focuses and sharpens energies. This exhibition presents the work of six mature artists with well-developed concepts of drawing that serve particular needs or functions. Each of the six has created a radical interpretation and amalgam of themes, some of which are particular to traditional drawing and some to the individual artist's view of drawing: none could have been anticipated or expected.

■

Robert Morris has dark fantasies that expand and touch reality. His recent work has focused on varieties of apocalypse, beginning with a musing on Leonardo's *Deluge* drawings, transforming the idea to nuclear apocalypse, and continuing to other more personal and natural visions of disaster.

Existential dread, natural disaster, and anger at society are objectified in Morris's work in a unique way. Like Jasper Johns, who first proposed the theme of existential doubt and duality in his monumental drawing *Diver*, 1963 (Collection Mr. and Mrs. Victor W. Ganz), where there is an actual imprint of the artist's hands and feet on the work, in drawing Morris reaches out from the center of himself to touch the world, de-

manding we all share in his visions. In his drawing from the Firestorm series, charcoal, graphite, ink, and wash virtually become the smoke, soot, and ash of a nuclear blast. Fear comes to life. The artist has noted that he physically generates heat as he rubs the surface of his drawings with powdered graphite; heat becomes a metaphor for creation and destruction. Dealing with what is at his fingertips and testing the extent of his physical reach Morris finds the scale of his work. In his drawing primordial sensations are brought to light and find virtual existence in the materials of drawing; touch and sight are related, but distinct, and order is created by representing external phenomena: echoes of Joseph Mallord William Turner's late works appear in several recent pastels. Other aspects of Morris's imagery—all permutations of the same subject —are death and sex, sex and power, power and repression, and repression and freedom. They are all culturally "framed," and literally framed.

In the frames that are an integral part of some recent work, Morris reaches out to the physical world. Using relief sculpture, which traditionally functions as a medium between two and three dimensions, he offers cast representations: skulls, skeletons, penises, ropes, and chains. Hand casts and finger tracks in the ductile medium refer touch in drawing to touch in sculpture. In the color pastels and watercolors, the drawing sheds light on the frame, illuminates it as if from a kind of deep internal radiation, creating an animate spatial volume. Historical, philosophical, and metaphorical references are dense: we are reminded of Baroque and Rococo styles but also of William Blake and the Pre-Raphaelites. We have here the relationship between drawing and relief sculpture in the dual presentation: the metaphor of touch, mentioned above, binds them, but even more arresting is Morris's conception of the role of art itself as a kind of conscience and provocation. The sculptural representations of bodily parts are casts which we must take to be the artist's metaphor for himself, a form of self-portraiture. These refer us to human sexuality and creation, to birth on the one hand and mortality on the other. The drawings are a creation, something to which the artist gives

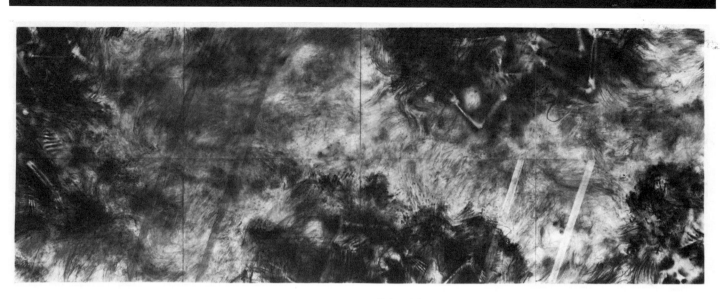

birth. They stand out against the mortality they portray.

■

Bruce Nauman has long been assumed to be the most subjective of artists, emptying his work of representation, making his own range of perception and consciousness the subject of his work. If the withdrawal into self is the "last freedom," then Nauman would seem to have achieved it. But why, then, would he describe drawing, that most personal of the arts, as a "privileged place, an open area, that he can step into and feel O.K.?" Why would he describe it as "a comfort?"

Far from withdrawing into self, this artist has offered himself in the form of his own fantasy, has invited us to play along with him. He has turned the world inside-out for our examination, named and objectified nameless fears, suspended the rules that govern his work, and taken time to meditate on what he has made, thus creating a place for the unexpected. In his sculpture Nauman has addressed the notion of space: the space things occupy, the space between things, and the space inside things as defined by their outsides. His drawings, too, are about the space things

Robert Morris. **Untitled (from the Firestorm series)**. 1982. Charcoal, ink, graphite, and pigment and wash. 76" × 16'. The Museum of Modern Art, New York. Gift of the Mr. and Mrs. Samuel I. Newhouse Foundation.

Inside the volume of two handfulls a gas with the density of metal expands faster than any known thing in the Universe. Giving up its binding force of energy a small chunk of dull gray metal rearranges itself into every nameable element. Time is drawn backwards into the void for an instant as matter is emptied into energy.

Outside streetcar rails melt and roof tiles boil as the city shudders for an instant before the bursting pressures and ensuing firestorms. Not all life is obliterated. A burnt and naked man stands on a black river bank holding his eyeball in his palm unable to see the beauty that reversing the Universe held for some.

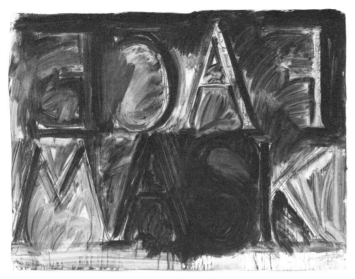

Bruce Nauman. **Face Mask**. 1981. Charcoal, pastel, and pencil. 52 ¾ × 70″. The Museum of Modern Art, New York. Gift of The Lauder Foundation. (Photograph: Glenn Steigelman Inc., courtesy Leo Castelli Gallery)

occupy, but they also represent the things that occupy space: they represent the sculpture. In his drawing Nauman attaches himself to certain traditions of art, practices skill, a certain degree of illusion, and can sometimes be allegorical.

Nauman's *Face Mask* is a calligram. "It brings text and shape as close together as possible. It is composed of lines delimiting the form of an object while also arranging the sequence of the letters. It lodges statements in the shape of a space, and makes the text say what the drawing represents."[1] This drawing is more than a "split representation";[2] it enacts duality. *Face* is mirrored, *Mask* is not; we see front and back, top and bottom, inside and out. *Face* is a projection as our own faces are to us in the mirror; from the front we see only the mask. Nauman, however, does not represent the mask as such, but demands that we join in, that we supply all kinds of additional verbal and visual information belonging to the class *mask*. We imagine all of the functions and ramifications of masking: personation, impersonation, the hidden individual existence behind the social and cultural facade. The rendering itself enacts a tension of opposition in that the calligraphy is made impersonal, masked as a hand-rendered typeface.

Nauman's presentation for the catalog falls into the category of his calligram and anagram drawings, and is meant to elicit many of the same kinds of responses as *Face Mask*. Since it is intended for mechanical reproduction it has been conceived, appropriately, in a mechanical typeface.

Face Mask conflates graphic and sculptural concerns; in this and as a physical object it joins another class of Nauman's drawings in which sculpture is presented as an object for meditation and the drawing itself is presented as a spatial object. In *Face Mask* the motif of disjunction is metaphorical; in other drawings it is semantic and literal, irreconcilable forms join to one another with seemingly seamless logic, circular section to rectangle, rectangle to triangular section. Actual physical disjunction is achieved by "piecing." Pieces added as "extenders" are not strictly collage, but they disrupt the flatness of the sheet and the integrity of

the plane and alter the neat rectangle. Concerns for density, surface and weight, and sheer size carry over. But Nauman's drawing is about things that do not at first emerge in the sculpture—if at all—so that new information is important and may emerge as just a sketch. Ultimately, Nauman wants to push us always a little beyond the range of our normal perceptions, to threaten us with illogic and to throw us back inside ourselves: we are ultimately his co-conspirators, joined to the artist as a subject of his work. *Face Mask* is enigmatic; its duality masks fantasies and conflicts. It is about magic: to put a face on fear is to exorcise it. Art here no longer functions as a closed rational system for representing the world, but as a system of interrogation: there are no closed categories; things attach to one another without apparent logic; there are no ultimate solutions.

■

James Rosenquist reminds us of the allusive power of images. His drawings are studies of the interpenetration of modes of representation, photographic and hand, imitative and abstract. He is the only artist in the exhibition who makes studies for his paintings. His drawings frequently mix technical means and mediums. They always mix motifs, deconstructing and reconstructing in an effort to devise another experimental space, one encompassing the plane surface of the canvas and the "voluminosity" of the world.

His motifs are selected from the world of popular advertising imagery, from images constantly reproduced in magazines, newspapers, and billboards and from photographs he takes himself. Disparate images are freely associated and assembled to create a composition that depends on layering and transparency, contrast and contiguity. Rosenquist draws after the photograph as traditional artists have drawn after nature.

In our culture we often confound the real with the photographic; although we have never seen her, we *know* how Marilyn Monroe looks because of photomechanical reproduction. The knowledge of what some-thing looks like doesn't come from firsthand sight. What is pictured is real: things *are* their pictures and the pictures are those things, in a continuously reflexive and fictional relationship. The photograph selects its own reality and, from a continuous fabric of the world, transposes it to two dimensions and frames it. The photomechanical reproduction makes it possible for anything in the world to go anywhere in the world, where familiarity levels all things. All images become equal, resulting in instant collage motifs and a dissolution of the distinctions among the traditional categories of still life, portrait, landscape, and figure composition.

Rosenquist takes advantage of the selective realities and the fictional relationship between the photoimage and reality, but he also works to break down the reflexive relationship in a recognition of the fiction. He creates a convincing transposition from one reality to another, from the mechanical to the hand-rendered. The lack of relative scale in the sizing of motifs is personal, psychological, and finally a spatial and visual assertion of the frontality of the pictorial surface, despite danger from the illusionistic void. Working in magnified size creates a perceptual distortion that destroys normal object identities and relationships, rendering them not only abstract but without significant content or thematic or narrative relationships. Fundamental to Rosenquist's work is the ambiguity inherent in the formal use of a specific image.

Rosenquist works from grisaille to color, from the individual motif to the total composition, in a series of steps. The first step consists of notations of ideas and sketches (sometimes left for years until suddenly something reveals itself), like those in his catalog presentation. At this stage drawing is about "revelations" and "evidence of feeling." He tries, without getting involved in style or technique, to leave a "significant suggestion of himself." Where Nauman is task-oriented, Rosenquist is systematic. The long process toward "a new visual idea, a new visual technique" follows, with the possibility of change and variation at every point. This involves studies of individual motifs (from photos and photomechanical reproductions), combinations of motifs, and finally

drawing these into a seamless whole. At this stage everything is tonal, and there is a great sensitivity to nuances of light. Next comes translation to color and, finally, enlargement to canvas. All along Rosenquist tries to retain the fidelity, the spontaneity, the wit, and the scale of the first little sketch.

The drawing for *Digits from the Wildwood*, a charcoal drawing after a collage, is a kind of interlocking spatial "sandwich." His intention is to intersperse two or more completely dissimilar motifs or textures in such a way as to provoke a sparkle at their point of intersection—to provoke a new pictorial idea, a new invention in the picture plane. The "flash of exploding smiles" tears apart the image, creating "digits," Rosenquist's word for the long spiky elements that result from cutting freely into an image and which he likens to scribbles of hatching and crosshatching in Rembrandt's work. His female visions are breaking up with laughter. We have a multilevel rendering because we are entering a mental space and looking in at what is seen; we are outside the picture looking at it as an object. The textural detail of skin here is not unlike an enlarged handmade version of the grainy printed texture of the skin in a cosmetic-ad reproduction. Rosenquist's silvery rendering smooths the sharply contrasted motifs into an overall uniform calligraphy and soft chiaroscuro. Rosenquist works from the reality that inheres to photography to the reality that inheres to drawing, and finally to the reality that inheres to painting. One suspects that ultimately Rosenquist sees continuity rather than fundamental difference among them—even a mystic unity in light. The artist says he is not inspired by nature, but by sunlight.

More importantly, the appropriation of the mechanical and the mimicry of its effects throughout the long process of bringing the mechanical "to hand" do two things: Rosenquist's paintings enact a tension between the mechanical and human both as a function of iconography and as a question of the working process itself as an underground subject. In his paintings the seemingly beneficent icons of popular culture are, in effect, rendered obscene in that they are smoothed over, emptied of significant detail. As a result, our sense of propriety is offended and high art is subverted in a manner that is, somehow, menacing. But are Rosenquist's paintings cautionary tales that point to other meanings—even to a kind of reconciliation with the dangerous mechanism of the modern world? Andy Warhol wanted to be a machine for making art. Is Rosenquist saying that it is all imitation, mimicry, anyway? I am a camera: I—the artist—see and mechanically, like a camera, record the image and then copy it by hand. Is Rosenquist telling us that it makes no difference, that I—the artist—am, have always been, the perfect machine for making art? Or is this what he resists?

■

Robert Ryman emerged in the late sixties as one of the leading painters of what was called at the time Minimal Art, characterized by a reduction of means to simple repetitive forms. It was an art with no ties to representation. Ryman, unswayed by current figurative trends, has continued to refine his characteristic monochromatic white paintings in startlingly beautiful new variations. He seldom makes drawings, although drawing has always been implicit in his paintings as the equation of paint and mark and as an underground principle of organization in their boundaries and divisions. For this exhibition and the catalog that accompanies it he has undertaken a reexamination of the possibilities of drawing for its own sake.

"Even the most perfect reproduction of a work of art is lacking in one element: its presence in time and space, its unique existence at the place where it happens to be."[3] If this is true for art in an "age of mechanical reproduction," it is particularly critical and matters a great deal to Ryman. The drawings Ryman made for this catalog present a clear case of opposition to the reproducibility of art. The support for each drawing is an anodized aluminum plate, square in format, to be hung ½ inch from the surface of the wall at a height of 60 inches to the center; the mediums used are pencil, ink and brush, ink wash, and enamel. The

emphasis is on each drawing as a unique object that inhabits space in a very particular way. Its "aura" is dependent on the realization that it is not, in the sense of a drawing on paper, a portable object, nor is it transferable to the pages of a book. Its essence is dependent on placement and unique presence. The composition is not internally focused. As a result, the viewer's reaction to it is not directed to a pictorial illusion but to something taking place between the picture's structure and himself. The interior is carefully bounded, whether by the surrounding line or the care with which each element touches the edge; you are made to feel and focus on the surface almost as if by direct command so that the surrounding space and distance from the wall become a necessary part of the experience, a breathing space that both contrasts with and intensifies the experience of the work. There is a kind of reflexive relationship. You sense the thickness of the metal plane, feel the size and shape and how it is distinguished from the wall, then begin to focus on the marks. The experience is not translatable to a reproduction, and Ryman resists the notion that any drawing, which is by his definition a unique object, can be reproduced.

Traditionally, in drawing, the white sheet serves as the lightest part of an image; the black drawing line and the various devices used for indicating shadow bring an illusionary volume to life. In certain of Henri Matisse's drawings, for instance, black line alone brings form to life, transforming white paper into light and volume. While Ryman admires Matisse's economy of means, he is against illusionism. Real light and shadow are mediums for Ryman. He wants to differentiate drawing devices specific to each medium and material but also "to find a system of equivalences." He feels that each medium and each material must somehow be appropriate to its use. The use of aluminum as a support challenges the fragility and impermanence of drawing. Light reflected from an aluminum surface is real light, and for Ryman light equals space: at one moment the aluminum surface is tough and resistant, in another it dissolves into sheer light—volume—itself.

Ryman has been investigating other traditional topics of drawing, "privacy," for instance, the idea that line by itself is signatory: several of these drawings are the artist's signature. The critic Jeremy Gilbert-Rolfe has noted that Ryman associates the linearity of painting with the linearity of text—an association that Ryman makes literal with his signature—which is not to say that his work should be read as allegory. Ryman's gesture in painting seems both to reject and embrace autography—reject it by repetition of the same mark within a single work but embrace it by the idiosyncratic nature of each gesture and by varying the gesture from painting to painting. While the similarity of gesture in the single work makes it seem impersonal, it is precisely this distancing that gives Ryman's marks the authority of shared experience, joining the viewer to the artist. Kinesthetic experience, dependent on gesture, is a fundamental part of traditional drawing; pleasure in it usually depends on complex factors. In Ryman's drawing, where the whole experience lies between the viewer and the mark, with no intervening depicted subject, it is critical.

Ryman works in series: each drawing explores a separate concern, whether it is material or structural, and each reflects on the others. Ryman wants simplicity, he wants richness but not, as the critic Carter Ratcliff has noted, fussiness. He is deliberate; Ratcliff calls this the "deliberateness of lived-out intention," and it is a good description for the toughness and rigor of work where meaning inheres in every space and mark.

■

Pat Steir is both a poet and a painter whose mature work began around 1971 with ideas that continue to the present. Initially interested in Conceptual Art, she is still interested in art as research, the construction of verbal and visual information systems.

Her new drawings are sheerly visual. The opposite of Ryman's, they are essays in pure illusion as it filters through history. They are about what she calls the net of style, the grid of style and subject matter, what slips through from the long tradition of art and the conventions tied to each time to make each artist's

personal gesture. There is no "innocent" eye. For this catalog she wrote:

> These drawings are quotations
> from the Japanese woodcut and from Hiroshige
> and from Courbet they each called their
> artworks *The Wave*
> I use artworks and often double quotations
> as reference material
> the repetition of a subject or image
> is very human and binding
> I always use images which while they remain intact
> can be seen as figuration at once
> this is especially suited to drawing.

Steir calls a recent series of drawings *From the Sea*. She writes: "They are terrifically athletic, like swimming both large and gestural and small and detailed in one motion." For Steir the "sport" of drawing serves the purpose of physically working out anxiety—of practicing freedom. She works with a large sheet of paper stapled to the wall. The gesture itself originates in her body, in its size and reach, and ends with the mark of the pencil she is holding as an extension of her finger. For Steir, the notion that any mark, group of marks, a line or cluster of lines, whether black or colored, could represent something else or could, indeed, stand on its own as meaningful is, on the face of it, absurd. Although for Steir drawing is "just marks, and that's that," and although her marks don't always describe edges or forms, they do "pretend to be something else." In these drawings pencil *is* water. Illusion plays on illusion, first the illusion that lead pretends to be water and "then the illusion that that has meaning."

Her drawing method deliberately courts chaos within a conceptual framework. As the lines accumulate there is always the possibility that the result will not be order but will be the direct projection of the primal notions that are its material. Although the execution is spontaneous it is somewhat ritualized. The drawings are highly conceptualized in advance; nevertheless they are pushed to the limit. There is no advance concept of finish in the sense of realizing the motif at a fixed point in time and space; rather, finish becomes a question of satisfactory visual incident, of

sufficient richness. Poetry scrawled onto the surface mixes with the marks of the drawings, extends into signs, and finally merges with the marks of the drawing itself.

As she works, Steir is overcoming the resistant surface, making it dissolve into light and space. As her marks accumulate and begin to create darker areas, little sparks of light appear at the intersections of the lines; the play between dark and light areas creates a movement like that of light playing on the surface. Space appears around the lines. Each frame, or "field," demands a different kind of concentration. One demands concentration close up within its confining outline; it fills the visual field with greater incident of detail. The other demands the conceptualization of a total image. The dual representation elicits a complex interplay of reflex and reflection, close involvement and detachment. (For the catalog she "cut a large drawing into sections wishing to show the whole gesture and essence of a large drawing through a few details.") The body is involved at actual scale. The line comes alive; it is both line and wave: the very stuff of illusion.

■

Robert Wilson is a performance artist and producer who came to critical attention in 1976 with *Einstein on the Beach*, a five-hour opera created in collaboration with composer Philip Glass and presented at the Metropolitan Opera House in New York. *Einstein* focused many aspects of performance art now accepted as basic to avant-garde performance and opera.

Wilson trained as an architect and was a painter; like a number of other artists in the seventies he began to prefer working in the performance medium, opening his art into three dimensions, extended time, real movement, sound, and live figures. Wilson is a contemporary innovator in the tradition of the "total artwork" as it was conceived initially by artists and by the innovators and giants of the modern theater in the first decades of this century. He belongs to the tradition of men such as Edward Gordon-Craig who abolished actors and static painted sets; and to that of

the Italian Futurists and the Russian Constructivists who first experimented with a metalanguage and nonsense vocalization, made the actors into formal elements of the whole, and created performances in collaboration with advanced musicians. But a large element of the earlier work was sheer parody and spoofing of tradition. Wilson is the first to seriously and fully bring the concept of the artist's total artwork as a major art form, extended in time, to the grand opera tradition.

Drawing is Wilson's basic conceptual tool. While Morris and Nauman speculate on doom, Wilson, like Rosenquist, speculates on salvation. The figure not present in Wilson's drawing but present in all his recent work is the hero who has the power to affect the course of events, perhaps to be a savior. The hero is usually a shadow figure, his story an imaginative interpretation of the events of his life using his attributes as a pretext for numerous substories involving other figures and properties. Wilson's current savior is the guileless fool Parsifal from the Wagner "festival stage play." The drawings rehearse only the conditions under which these figures will appear. They deal with the transparent volume of the space of the stage, relating chiaroscuro drawing to the light and shadow of the stage space. Drawing automatically and obsessively, Wilson translates conceptually from one mode into the other, from space expressed in black-and-white drawing to its concrete spatial realization.

For a drawing exhibition at the time of the Rotterdam performance of Wilson's recent *CIVIL warS* the Dutch curator Wim Beeren asked, "Do Wilson's drawings represent theater? Are they an element of theater? Are they the stills of a theatrical process?" They are, in fact, all three—and more. As pure speculation—a form of random note-taking or doodling—they form a bank of ideas. The drawings accurately convey how each scene will look; drawings are realized as curtains, sets, drops, and properties for performances, and used for projection during performances. As stills they are the beginning of the theatrical process, and, sometimes, in drawings made after the performance, they become its reflection as well. They are a form of story-board, a series of rapid automatic sketches that proceed act by act, scene by scene, unfolding the story. They assure thematic unity and continuity; the structure once realized on the sheet in the tiny conceptual drawings is carried in mind as the governor of all the disparate elements of the production. For Wilson the pictorial is the underlying organizational principle of any production.

On stage Wilson works with a freedom of structural invention, with chance, and with contingent, even disjunctive, part-to-part structure, which derive from modern pictorial inventions as well as Dada and Surrealist performances and are rooted in the pictographic, filmic sequencing of the drawings. He works with collage, montage, and superimposition, with an assemblage of disparate parts, and with variations and repetition. He involves the spectator, requiring him to follow the "business" of construction and deconstruction that affects the logical flow of events, using what critic Franco Quadri has called "associative and disassociative principles in pursuit of an ideal of conceptual freedom."

The obsessive repetition and variation, the measured progression from frame to frame, scene to scene, is the sign and may be the source of the ritualistic character of Wilson's work. The absence of figures in most of the drawings, their anonymity—in effect, their silence—is a sign that no single actor is central to a Wilson work.

The drawings do not depict figures and the stage figures are impersonal, yet theater as an art form is the medium par excellence for the human form. Thus, in a crisis of choice between an apparently radically nonfigurative art such as Minimalism and a need for figuration, performance art (an extension of the viewer's role in Minimalism) must have seemed to Wilson, as to other artists of the late sixties, a natural solution to conflicting factors.

In a Wilson performance the props are as much personae as the actors. The vocal parts are there for sound. The characters appear, vocalizing, but the figures seem arbitrarily dispersed; they are neutral, not fully realized dramatic personalities, parts of a mea-

sured whole. The slow ritualistic movement of figures and the changes of light and properties, all meshed into a total fabric, reveal the pictorial rather than the dramatic as the source of inspiration. Graphite and charcoal are Wilson's drawing mediums; light is his stage medium. He works with light onstage as if "drawing." The pictorial realization of a performance is a full translation of the drawings into the space proper to the stage; at times there is even a literal translation of the chiaroscuro of the drawings into the stage lighting.

Wilson's life is highly mobile, his drawing portable; he moves from city to city working on productions, keeping the creative process alive over long periods of time. But if the drawings involve Wilson's process of the creation of the dramatic spectacle, they at the same time involve themselves. Wilson likes drawing as drawing. He likes the velvet blacks, the dramatic line, the sheer material quality of the medium, the instruments he works with, and the paper itself. He likes the sensual quality and probably the privacy. The grand designs that can only be accomplished with the collaboration of hundreds of people here find their private beginnings and their summation.

■

A note on the catalog: Most of the drawings included in the exhibition were not available for illustration in the catalog, so I asked each artist to make drawings specifically for the catalog within a given but flexible format. Because four of the six artists in the exhibition draw to large size, the catalog was conceived to provide as much drawing area as possible as well as to simulate the usual drawing formats of each. Nevertheless, the limitations of page size focused certain issues. The major factor affecting the size of the drawings of Steir, Morris, and Nauman is the gesture which, in the work of each artist, is generated by the whole body in movement. For them (and for Rosenquist, although in a different way since he plays with transformations of scale) size is a critical issue. It forces the viewer to a new kind of experience, one that even

moves outside the normal field of vision and normal physical, perceptual limits. Its object is to make the experience of looking less predictable and manageable —to keep it open and moving—and ultimately to change our expectation and experience of drawing. Cutting down size meant cutting down the gesture to scale—an uncomfortable idea, as it turned out.

Steir solved the problem, as she noted herself, by making a large drawing and cutting it to size. Morris, also, did not feel comfortable about reducing the scale of his work. He suggested one-to-one scale reproduction of an existing drawing. That turned out to be a misrepresentation since another part of the issue (also raised by Steir) is "normal" sight distance established by the work itself. He finally compromised on details scaled at the "normal" distance from the object. Nauman solved the problem in a very direct manner, giving us a reproduction—a direct typographical production—as an artwork. This has the effect of reinforcing Ryman's viewpoint. Rosenquist dealt with the problem by treating the catalog as a form of the preliminary note-taking he normally follows in creating new work. For Wilson "size"—on stage—equals duration in time expressed by light. In his drawing, size has to do with multiplication: the production of many small drawings in minute variations and in seemingly inexhaustible numbers. For him the catalog format worked better but is probably too limited in the number of drawings shown.

—B. R.

1. Michel Foucault, "The Unraveled Calligram," in *This Is Not a Pipe*, trans. and ed. James Harkness (Berkeley, Los Angeles, London: University of California Press, 1983), pp. 20-21.
2. Claude Lévi-Strauss, quoted in David Shapiro, *Jasper Johns Drawings 1954–1984* (New York: Harry N. Abrams, Inc., 1984), p. 55.
3. Walter Benjamin, "The Work of Art in the Age of Mechanical Reproduction," in *Illuminations*, ed. and intro. Hannah Arendt; trans. Harry Zohn (New York: Schocken Books, 1969), p. 220.

Robert Morris

Born 1931, Kansas City, Missouri. Studied Kansas City Art Institute, 1948–50. Studied California School of Fine Arts, San Francisco, 1950–51. Studied Reed College, Portland, Oregon, 1953–55. Received M.A. (Art History) from Hunter College, New York, 1963. Lives in New York.

Selected Individual Exhibitions
1957 Dilexi Gallery, San Francisco **1964** Galerie Schmela, Düsseldorf / Green Gallery, New York **1967** Leo Castelli Gallery, New York **1968** Stedelijk van Abbemuseum, Eindhoven / Galerie Ileana Sonnabend, Paris **1969** Galleria Enzo Sperone, Turin **1970** Whitney Museum of American Art, New York **1971** The Tate Gallery, London **1972** Leo Castelli Gallery, New York **1973** Galerie Konrad Fischer, Düsseldorf **1974** Art in Progress, Munich **1976** Leo Castelli Gallery, New York **1977** Stedelijk Museum, Amsterdam **1979** Ileana Sonnabend Gallery, New York **1980** The Art Institute of Chicago **1983** Leo Castelli Gallery, New York / Rijksmuseum Kröller-Müller, Otterlo **1984** Padiglione d'Arte Contemporanea, Milan **1985** Leo Castelli: 142 Greene Street and Ileana Sonnabend Gallery, New York

Selected Group Exhibitions
1966 *Primary Structures*, The Jewish Museum, New York **1968** *Documenta 4*, Kassel **1969** *Pop Art*, Hayward Gallery, London / *New York Painting and Sculpture: 1940–1970*, The Metropolitan Museum of Art, New York / *Op losse schroeven*, Stedelijk Museum, Amsterdam / *When Attitudes Become Form*, Kunsthalle,

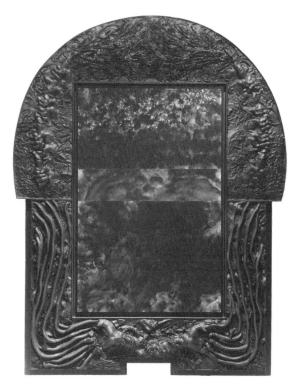

Untitled. 1984. Painted cast hydrocal and watercolor on paper mounted on canvas. 72 × 51 ¼". Collection Estelle Schwartz, New York. (Photograph: Jon Abbott, courtesy Ileana Sonnabend Gallery)

Bern / *Spaces*, The Museum of Modern Art, New York **1970** *Information*, The Museum of Modern Art, New York / *Conceptual Art, Arte Povera, Land Art*, Galleria Civica d'Arte Moderna, Turin **1971** *Works for New Spaces*, Walker Art Center, Minneapolis / *Sonsbeek '71*, Sonsbeek Park, Arnhem, the Netherlands **1972** *Diagrams and Drawings*, Rijksmuseum Kröller-Müller, Otterlo **1974** *Idea and Image in Recent Art*, The Art Institute of Chicago **1975** *Zeichnungen 3, U.S.A.*, Städtisches Museum, Leverkusen, West Germany **1976** *Drawing Now*, The Museum of Modern Art, New York **1977** *Probing the Earth: Contemporary Land Projects*, Hirshhorn Museum and Sculpture Garden, Washington, D.C. / *Documenta 6*, Kassel **1978** *Art about Art*, Whitney Museum of American Art, New York **1980** *Venice Biennale* / *Hauptwerke der Minimal Art*, InK, Zurich / *Sammlung Panza-Minimal Skulpturen*, Kunstmuseum, Düsseldorf **1981** *Westkunst*, Cologne / *Metaphor: New Projects by Contemporary Sculptors*, Hirshhorn Museum and Sculpture Garden, Washington, D.C. **1982** *Zeitgeist*, Martin Gropius Bau, Berlin / *A Century of Modern Drawing from The Museum of Modern Art, New York*, The Museum of Modern Art, New York **1983** *Twentieth-Century Sculpture: Process and Presence*, Whitney Museum of American Art, New York / *New Art*, The Tate Gallery, London / *The End of the World: Contemporary Views of the Apocalypse*, New Museum of Contemporary Art, New York **1984** *Via New York*, Musée d'Art Contemporain, Montreal

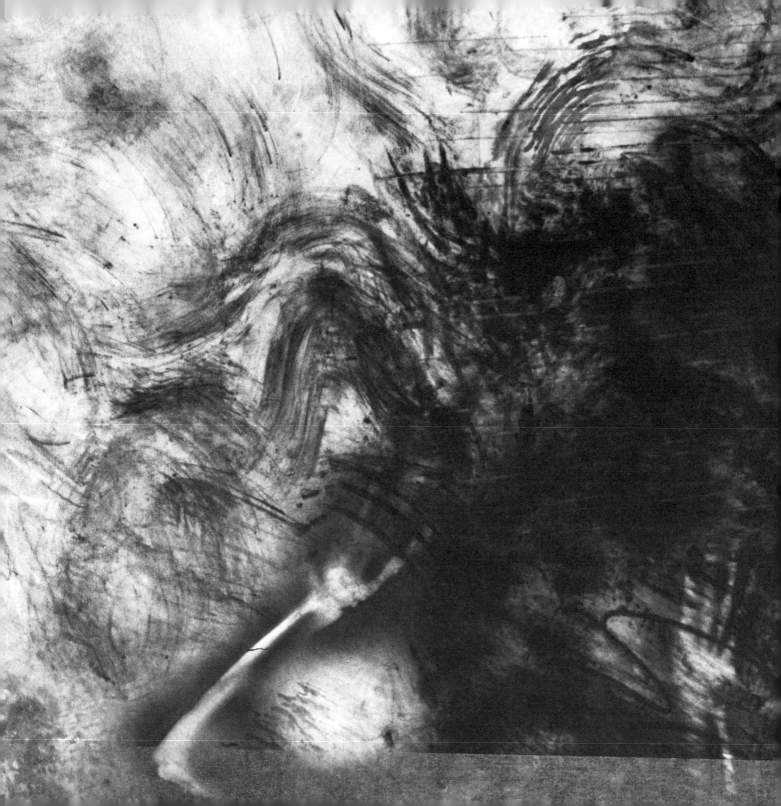

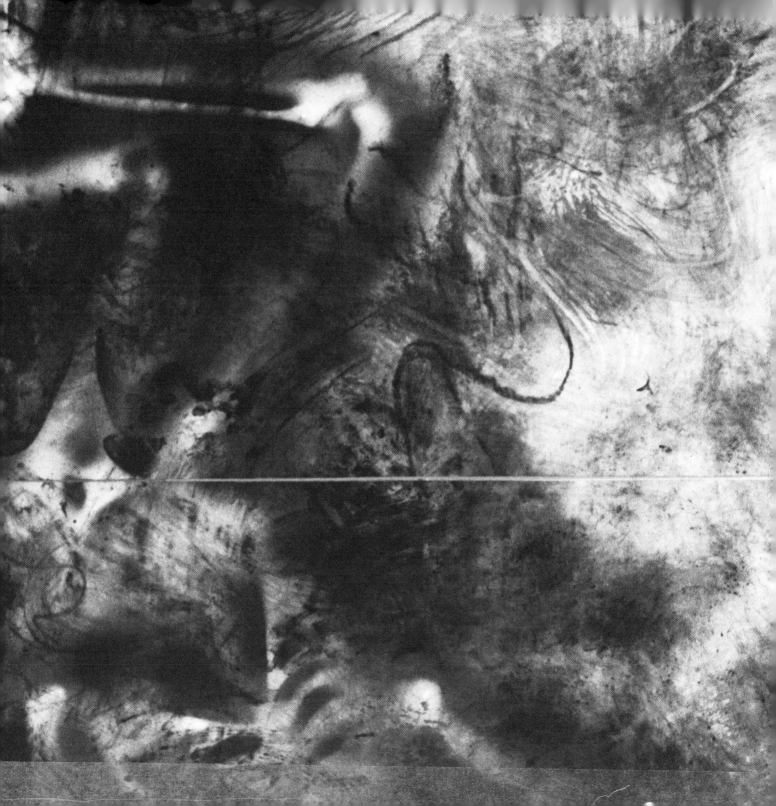

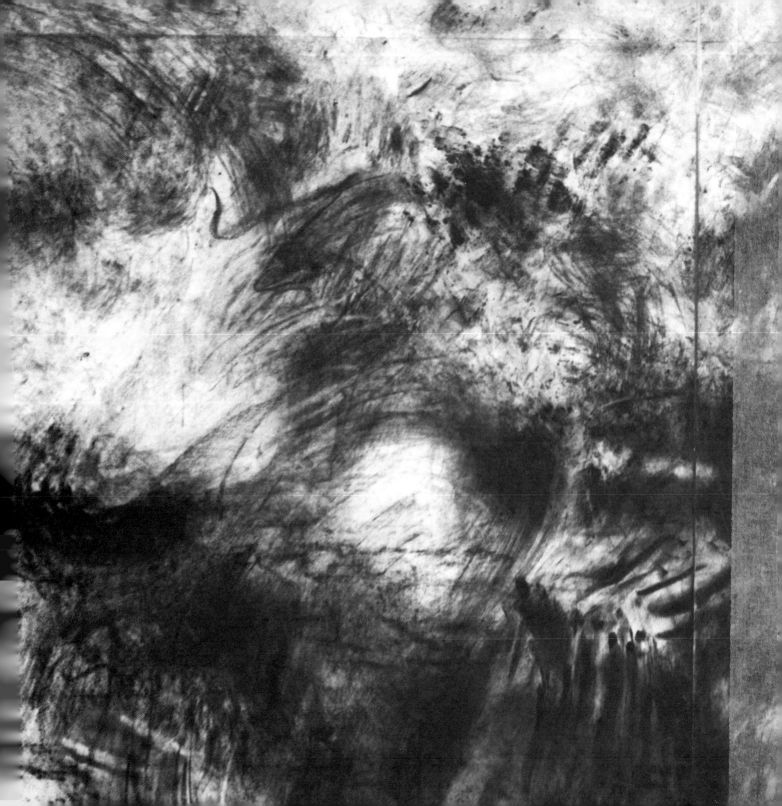

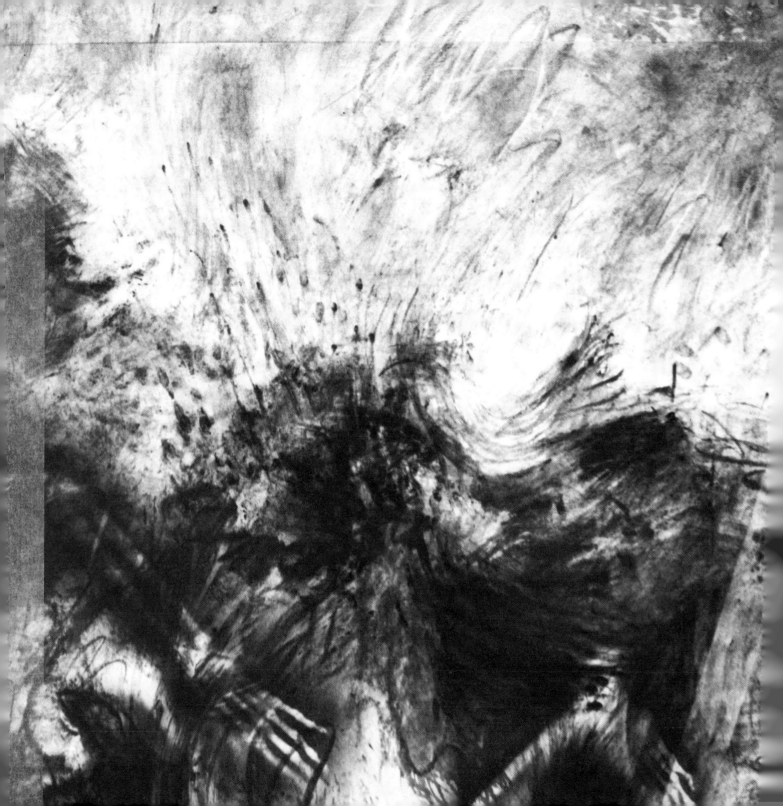

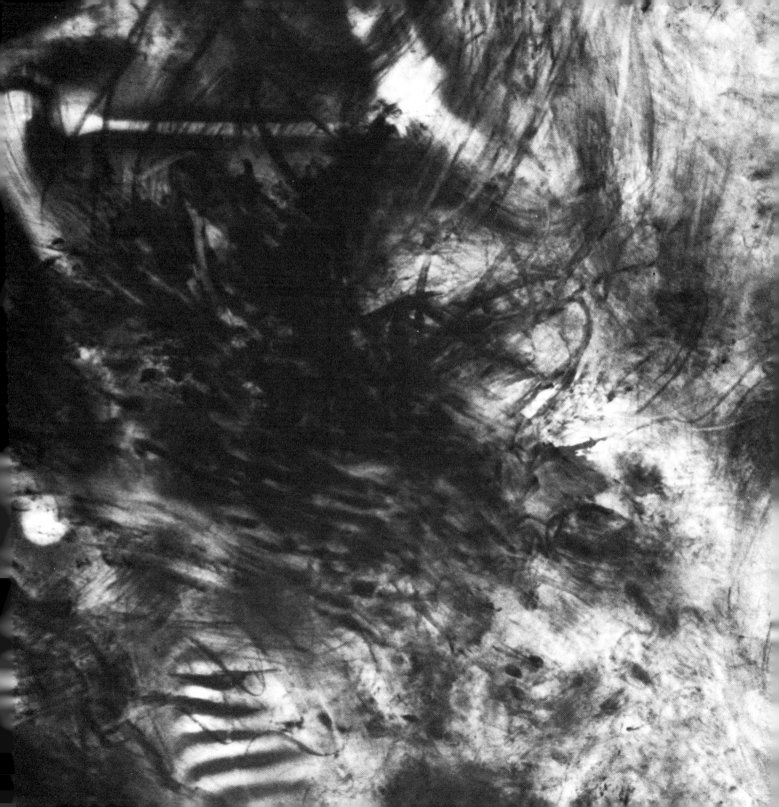

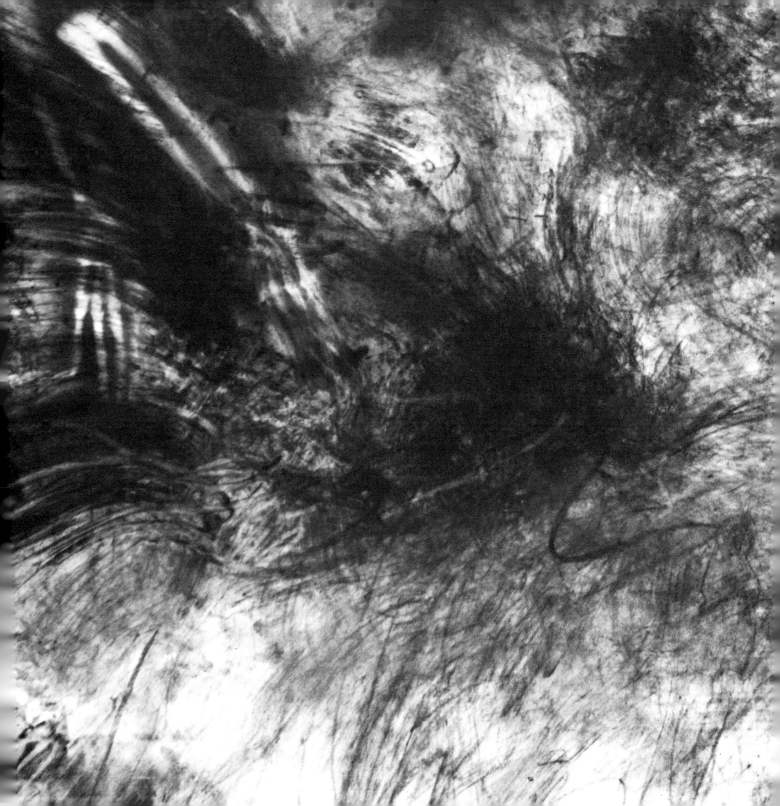

Bruce Nauman

Born 1941, Fort Wayne, Indiana. Received B.S. from University of Wisconsin, 1964, and M.F.A. from University of California, Davis, 1966. Lives in New Mexico.

Model for Stadium. 1984. Painted wood and plaster. 29 ½ × 93 ½ × 65". Courtesy Leo Castelli Gallery, New York. (Photograph: Dorothy Zeidman)

Selected Individual Exhibitions
1966 Nicholas Wilder Gallery, Los Angeles 1968 Leo Castelli Gallery, New York/ Galerie Konrad Fischer, Düsseldorf 1969 Galerie Ileana Sonnabend, Paris 1970 Galleria Enzo Sperone, Turin/Galerie Ricke, Cologne 1971 Galerie Bruno Bischofberger, Zurich 1972 *Bruce Nauman: Work from 1965–1972*, Los Angeles County Museum of Art; Whitney Museum of American Art, New York; Kunsthalle, Bern; Contemporary Arts Museum, Houston; San Francisco Museum of Modern Art 1973 Leo Castelli Gallery, New York 1974 Ace Gallery, Vancouver/Art in Progress, Munich 1975 *The Consummate Mask of Rock*, Albright-Knox Art Gallery, Buffalo 1976 Ace Gallery, Vancouver, Los Angeles, and Venice, California 1978 InK, Zurich 1979 Portland Center for the Visual Arts, Oregon 1981 *Bruce Nauman 1972–1981*, Rijksmuseum Kröller-Müller, Otterlo/Staatliche Kunsthalle, Baden-Baden 1982 *Bruce Nauman: Neons*, Baltimore Museum of Art, Maryland 1983 Krefelder Kunstmuseum, Museum Haus Esters, Düsseldorf 1984 Sperone Westwater, New York/Leo Castelli: 142 Greene Street, New York

Selected Group Exhibitions
1966 *William Geis and Bruce Nauman*, San Francisco Art Institute 1967 *American Sculpture of the Sixties*, Los Angeles County Museum of Art 1968 *Documenta 4*, Kassel 1969 *When Attitude Becomes Form*, Kunsthalle, Bern/*Op losse schroeven*, Stedelijk Museum, Amsterdam/*Anti-Illusion: Materials/Procedures*, Whitney Museum of American Art, New York 1970 *Information*, The Museum of Modern Art, New York/ *Whitney Annual: Sculpture 1970*, Whitney Museum of American Art, New York 1971 *Prospect '71*, Kunsthalle, Düsseldorf/*Sonsbeek '71*, Sonsbeek Park, Arnhem, the Netherlands 1972 *Documenta 5*, Kassel/*Diagrams and Drawings*, Rijksmuseum Kröller-Müller, Otterlo/ Kunstmuseum, Basel 1975 *Drawing Now*, The Museum of Modern Art, New York 1976 *200 Years of American Sculpture*, Whitney Museum of American Art, New York 1977 *Biennial*, Whitney Museum of American Art, New York 1978 *Made by Sculptors*, Stedelijk Museum, Amsterdam/*Venice Biennale* 1980 *Pier + Ocean*, Hayward Gallery, London; Rijksmuseum Kröller-Müller, Otterlo 1981 *Soundings*, Neuberger Museum, State University of New York, Purchase 1982 *Antiform et Arte Povera, Sculptures 1966–69*, Centre d'Arts Plastiques Contemporains, Bordeaux/*Documenta 7*, Kassel/*A Century of Modern Drawing from The Museum of Modern Art, New York*, The Museum of Modern Art, New York 1983 *Neue Zeichnungen aus dem Kunstmuseum, Basel*, Kunstmuseum, Basel; Kunsthalle, Tübingen; Neue Galerie, Staatliche und Städtische Kunstsammlungen, Kassel

End of the World. 1984.

Pay Attention. 1984.

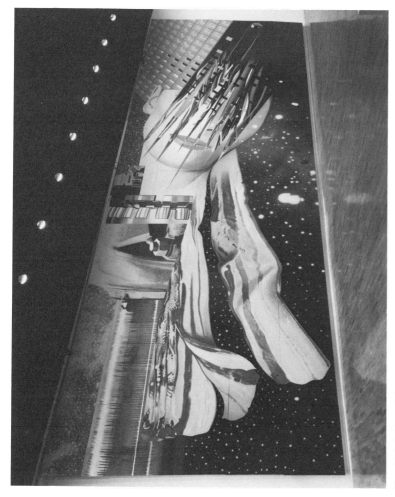

Star Thief. 1980. Oil on canvas. 17' 1" × 46'. Collection Art Enterprises, Inc. (Photograph: Bevan Davies, courtesy Leo Castelli Gallery)

James Rosenquist

Born Grand Forks, North Dakota, 1933. Studied painting University of Minnesota, 1952–53, and Art Students League, New York, 1955. Painted outdoor advertising in New York, 1957–60. Lives in New York and Florida.

Selected Individual Exhibitions

1962 Green Gallery, New York **1963** Green Gallery, New York **1964** Dwan Gallery, Los Angeles / Green Gallery, New York **1965** Galerie Ileana Sonnabend, Paris / *F-111*, Leo Castelli Gallery, New York; Moderna Museet, Stockholm; Stedelijk Museum, Amsterdam; Kunsthalle, Bern; Louisiana Museum, Humlebaek, Denmark; **1968** National Gallery of Canada, Ottawa **1969** Leo Castelli Gallery, New York **1970** Galerie Ricke, Cologne **1972** Wallraf-Richartz Museum, Cologne / Whitney Museum of American Art, New York **1973** Stedelijk Museum, Amsterdam **1974** Mayor Gallery, London **1975** Margo Leavin Gallery, Los Angeles **1976** Mayor Gallery, London **1977** National Gallery of Victoria, Australia **1979** Plains Art Museum, Moorhead, Minnesota / Albright-Knox Art Gallery, Buffalo **1980** Texas Gallery, Houston **1982** Castelli Feigen Corcoran, New York **1983** Leo Castelli Gallery, New York **1984** Thorden Wetterling Galleries, Stockholm **1985** Leo Castelli Gallery, New York

Selected Group Exhibitions

1962 *New Realists*, Sidney Janis Gallery, New York **1963** *Six Painters and the*

Object, The Solomon R. Guggenheim Museum, New York / *Pop Art USA*, Oakland Art Museum, California / *The Popular Image*, Institute of Contemporary Art, London **1964** *Amerikanst Pop-konst*, Moderna Museet, Stockholm / *Environment by 4 New Realists*, Sidney Janis Gallery, New York / *Painting and Sculpture of a Decade: 54/64*, The Tate Gallery, London / *Pop Art*, Stedelijk Museum, Amsterdam **1965** *Pop Art, Nouveau Réalisme, Etc.*, Palais des Beaux-Arts, Brussels **1967** *The 1960s: Painting and Sculpture from the Museum Collection*, The Museum of Modern Art, New York / *American Painting Now*, United States Pavilion, Expo '67, Montreal

1969 *Annual Exhibition of Painting*, Whitney Museum of American Art, New York / *New York Painting and Sculpture: 1940–1970*, The Metropolitan Museum of Art, New York **1974** *American Pop Art*, Whitney Museum of American Art, New York **1978** *American Painting of the 1970s*, Albright-Knox Art Gallery, Buffalo **1979** *Late Twentieth-Century Art from the Sidney and Frances Lewis Foundation*, Institute of Contemporary Art, Philadelphia **1981** *Internationale Ausstellung Köln 1981*, Cologne **1984** *10 Painters and Sculptors Draw*, Museum of Fine Arts, Boston / *Summer Exhibition: 20 Years of Collecting*, Stedelijk Museum, Amsterdam

Paper Disc to Collect Dust. 1984. Etching and aquatint, pen and ink.

Drawing for **Digits from the Wildwood.** 1984. Charcoal. 48 × 55". The Museum of Modern Art, New York. Ruth Vollmer Bequest (by exchange) and Purchase. (Photograph: Dorothy Zeidman, courtesy Leo Castelli Gallery)

Paper Trap. 1984. Etching and aquatint, pen and ink.

The Observer the Observed. 1984. Pen and ink.

Shelf Life. 1984. Etching and aquatint, pen and ink.

Hand Towel. 1984. Pen and ink.

Drawing notes:

Artists and deaf mutes deal with the speed of light so its boring to have things described back to them at the speed of sound.

paper disc or table to collect dust

Drawing notes: the priority is pictorial invention
crosshatching filled with imagery leaves space for more.

forms I thought I knew have to be ~~re-examined~~
re-exami.

Drawing notes: try to explain something to an extra
terrestrial being.

Letting snow fall in exactly the right place or
cleaning clouds out of the sky is letting God step
into ones work. Drawing from nature is Illuminating
God. Art is synthetic. Can I identify an accident?

paper box on a piece of paper.
paper traps to catch ideas.

Drawing notes: A title! the Observer the Observed
 after Einstein's theory of relativity.

 Drawing and pointing: the connection between
mind and stomach and brain and finger. the
pointer as accuracy- ZEN, marine corp pistol
practice, ability to describe by drawing.

 Human animals are still evolving and one is
allowed only a small bit of reception. The Shining!
a great movie because Jack Nicolsen character was
aflicted by many things, ESP, schizophrenia, poltergeists
and more. Ones body self destructing brings about
Illuminations. I saw beautiful things attributed to
eye trouble. John Cages piece titled Fontana Mix
Feed. I believe this work to be from a wall of
radio waves that crosses the Long Island Expressway.
 A parallel line drawing to paper.
A paper moving above a piece of paper.

Drawing notes: -the blind man with his living room
furniture;
Is it our own intuition, electricity or soul that we bring
to contemplate a work of art? Can I weigh it.

Charcoal door above a piece of paper
with a can that spills on ones head everytime
the door is opened. title - SHELF LIFE

notes: leaving intention on a hand towel after
many self conscious false drawing starts.

drawing paper
on roller

arrange dust to create an illusion

Robert Ryman

Born 1930, Nashville, Tennessee.
Attended Tennessee Polytechnic
Institute and George Peabody College,
1948–50. Lives in New York.

Index. 1982. Oil and enamel on fiberglass with aluminum. 43 ¼ × 40″. Collection E. A. Gutzwiller, Zurich. (Photograph: Allan Finkelman)

Selected Individual Exhibitions
1967 Paul Bianchini Gallery, New York
1968 Galerie Konrad Fischer, Düsseldorf/Galerie Heiner Friedrich, Munich **1969** Fischbach Gallery, New York/Galerie Yvon Lambert, Paris/Galleria Françoise Lambert, Milan/Ace Gallery, Los Angeles **1970** Fischbach Gallery, New York **1971** Dwan Gallery, New York/Galerie Heiner Friedrich, Cologne **1972** John Weber Gallery, New York/The Solomon R. Guggenheim Museum, New York/**1973** Galleria San Fedele, Milan/ John Weber Gallery, New York/Art & Project, Amsterdam **1974** Stedelijk Museum, Amsterdam/Westfalischer Kunstverein, Münster/Palais des Beaux-Arts, Brussels/John Weber Gallery, New York **1977** P.S. 1, Institute for Art and Urban Resources, Long Island City, New York/Galleria Gian Enzo Sperone, Rome/Galerie Annemarie Verna, Zurich/Whitechapel Art Gallery, London **1978** InK, Zurich **1979** Sidney Janis Gallery, New York **1980** Kunstraum, Munich **1981** Sidney Janis Gallery, New York/Musée National d'Art Moderne, Centre Georges Pompidou, Paris **1982** Kunsthalle, Düsseldorf **1983** Bonnier Gallery, New York **1984** Galerie Maeght Lelong, New York and Paris **1985** Rhona Hoffman Gallery, Chicago

Selected Group Exhibitions
1975 *Fundamental Painting*, Stedelijk Museum, Amsterdam/*Drawing Now*, The Museum of Modern Art, New York **1976** *Venice Biennale/Three Decades of American Art*, selected by the Whitney Museum of American Art, Seibu Department Store Gallery, Tokyo/*Rooms*, P.S. 1, Institute for Art and Urban Resources, Long Island City, New York **1977** *Biennial*, Whitney Museum of American Art, New York/*Documenta 6*, Kassel **1978** *American Painting of the 1970s*, Albright-Knox Art Gallery, Buffalo **1979** *The Reductive Object: A Survey of the Minimalist Aesthetic in the 1960s*, Institute of Contemporary Art, Boston **1980** *Andre, Dibbets, Long, Ryman*, Louisiana Museum, Humlebaek, Denmark/*Venice Biennale/Minimal and Conceptual Art from the Panza Collection*, Museum für Gegenwartskunst, Basel **1981** *A New Spirit in Painting*, Royal Academy of Art, London/*Westkunst*, Cologne **1982** *60's–80's*, Stedelijk Museum, Amsterdam/*Documenta 7*, Kassel **1983** *Abstract Painting: 1960–69*, P.S. 1, Institute for Art and Urban Resources, Long Island City, New York/*Minimalism to Expressionism*, Whitney Museum of American Art, New York **1984** Stiftung für Neue Kunst (Crex Collection), Schaffhausen, Switzerland/*La Grande Parade*, Stedelijk Museum, Amsterdam; The Solomon R. Guggenheim Museum, New York

Untitled Number 7. 1984. Enamel on anodized aluminum.

Untitled Number 3. 1984. Ink and enamel on anodized aluminum.

Untitled Number 8. 1984. Graphite pencil on anodized aluminum.

Untitled Number 6. 1984. Ink and enamel on anodized aluminum.

Untitled Number 2. 1984. Ink on anodized aluminum.

Untitled Number 4. 1984. Ink on anodized aluminum.

(Photographs: Kate Keller)

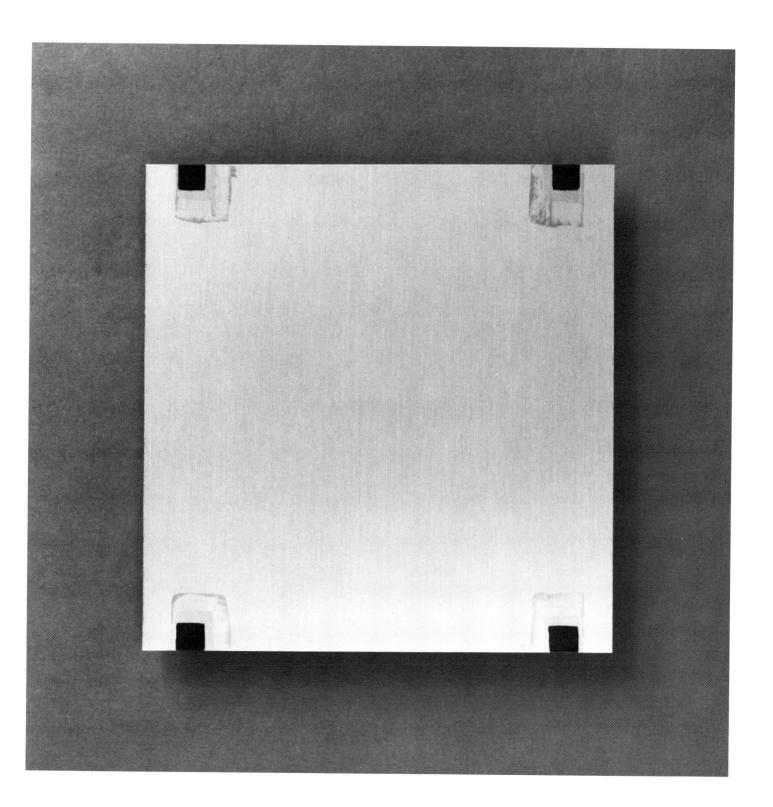

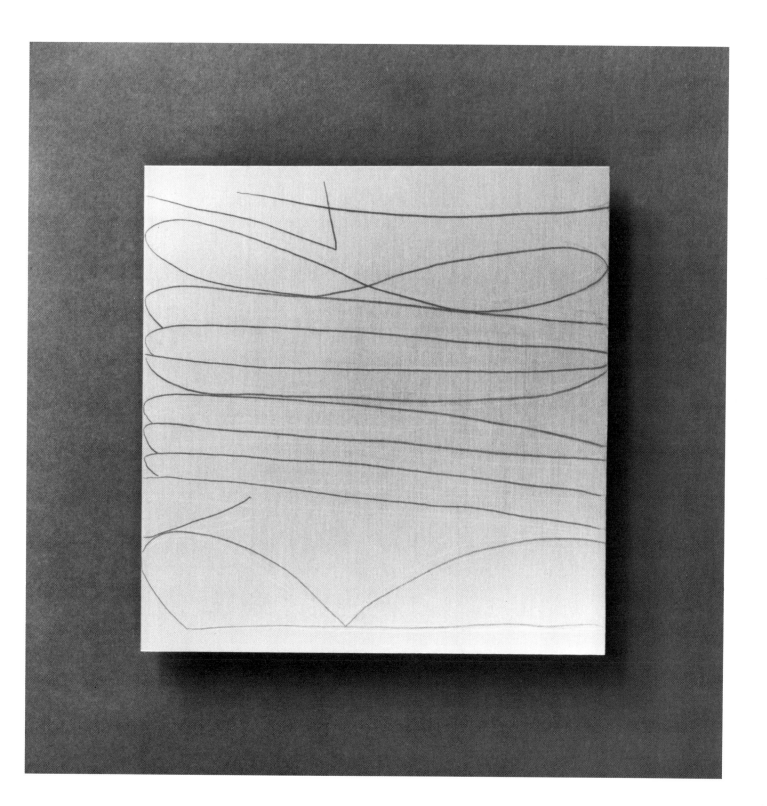

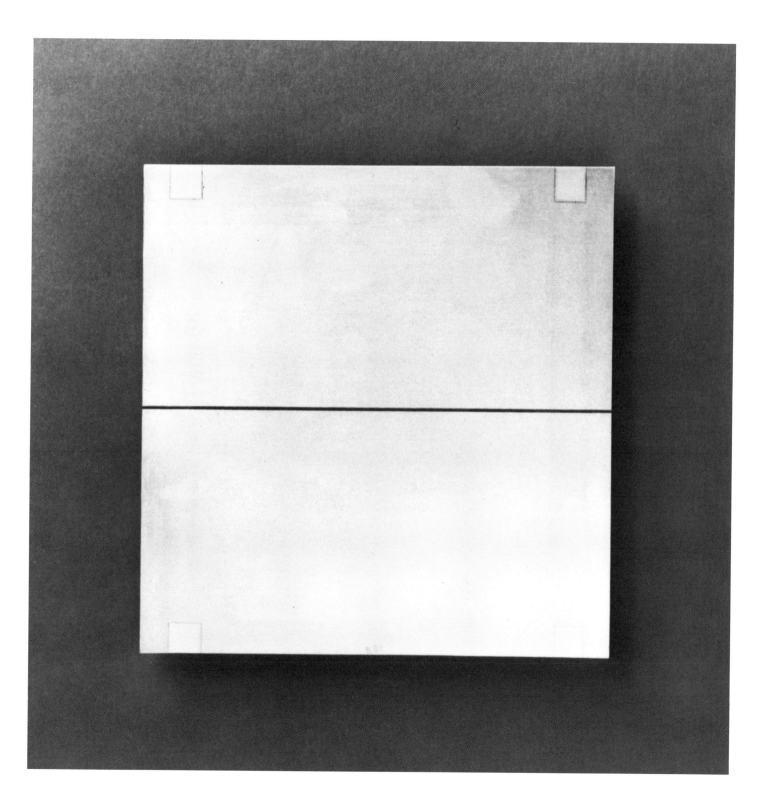

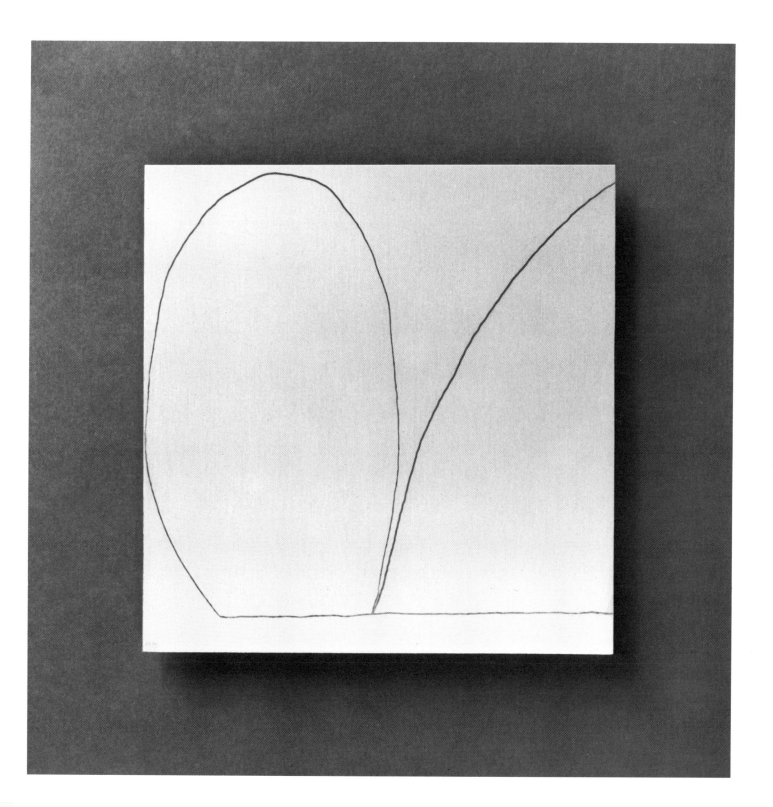

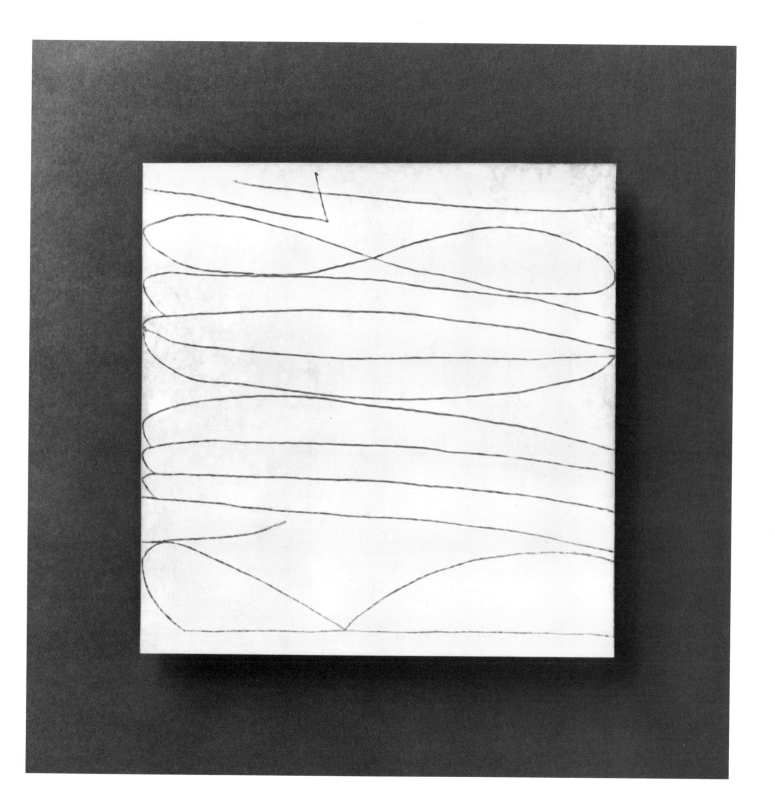

Pat Steir

Born 1940, Newark, New Jersey. Studied Pratt Institute, Brooklyn, Boston Museum School and Boston University, Massachusetts, 1956–62. Received B.F.A. from Pratt Institute, 1961. Lives in New York and Amsterdam.

The Brueghel Series (A Vanitas of Style). 1984. Series of 71 panels: 1 panel, pencil on poster, 28 ⅜ × 22 ¼"; 16 monochrome panels, oil on canvas, each 27 ¾ × 21 ¾"; 64 polychrome panels, oil on canvas, each 28 ½ × 22 ½". Collection the artist. (Installed at The Brooklyn Museum, 1984; photograph: Peter Muscato)

Selected Individual Exhibitions
1964 Terry Dintenfass Gallery, New York 1971 Graham Gallery, New York 1972 Paley & Lowe, Inc., New York 1973 Corcoran Gallery of Art, Washington, D.C. 1975 Fourcade, Droll, Inc., New York 1976 Galerie Farideh Cadot, Paris/Otis Art Institute, Los Angeles 1978 Droll/Kolbert Gallery, New York/Galleria Marilena Bonomo, Bari, Italy 1979 Galerie Farideh Cadot, Paris 1980 Max Protetch Gallery, New York/ Galerie d'Art Contemporain, Geneva 1981 Galleriet, Lund, Sweden 1982 Galerie Annemarie Verna, Zurich 1983 *Form, Illusion, Myth: The Prints and Drawings of Pat Steir*, Spencer Museum of Art, University of Kansas, Lawrence; University Art Museum, California State University, Long Beach; Contemporary Arts Museum, Houston; Wellesley College Museum, Massachusetts; Brooks Memorial Art Gallery, Memphis/*Arbitrary Order: Paintings by Pat Steir*, Contemporary Arts Museum, Houston; Lowe Art Museum, Coral Gables, Florida; Contemporary Arts Center, Cincinnati 1984 Van Straaten Gallery, Chicago/Barbara Farber Gallery, Amsterdam/The Brooklyn Museum, New York 1985 Joslyn Art Museum, Omaha/ University Art Museum, University of California, Berkeley/Cincinnati Art Museum

Selected Group Exhibitions
1963 High Museum of Art, Atlanta 1964 *Drawings*, The Museum of Modern Art, New York 1966 Terry Dintenfass Gallery, New York 1970 French and Company, New York 1972 *American Drawings 1963–1973*, Whitney Museum of American Art, New York 1974 *Joan Snyder and Pat Steir*, Institute of Contemporary Art, Boston 1976 *16 Projects/4 Artists*, University Art Museum, California State University, Long Beach 1977 *Biennial*, Whitney Museum of American Art, New York/ *Drawings of the 70s*, The Art Institute of Chicago/*A Painting Show*, P.S. 1, Institute for Art and Urban Resources, Long Island City, New York 1978 *Contemporary Drawing/New York*, University Art Museum, University of California, Santa Barbara/*American Painting of the 1970s*, Albright-Knox Art Gallery, Buffalo 1979 *The 1970's New American Painting*, New Museum of Contemporary Art, New York 1980 *American Painting of the 60s and 70s*, Whitney Museum of American Art, New York/ *American Drawings in Black & White: 1970–1980*, The Brooklyn Museum, New York 1982 *Geometric Art at Vassar*, Vassar College Art Gallery, Poughkeepsie, New York 1983 *Sex and Representation*, A Space, Toronto/*Biennial*, Whitney Museum of American Art, New York/*ARC Exhibition*, Musée d'Art Moderne de la Ville de Paris 1984 *Content: A Contemporary Focus, 1974–1984*, Hirshhorn Museum and Sculpture Garden, Washington, D.C./ *American Women Artists Part II: The Recent Generation*, Sidney Janis Gallery, New York/ *Art of the Seventies*, Whitney Museum of American Art, New York 1985 *A New Beginning: 1968–1978*, Hudson River Museum, Yonkers

Sections of **Untitled Drawing (Water)**. 1984.
Pencil.

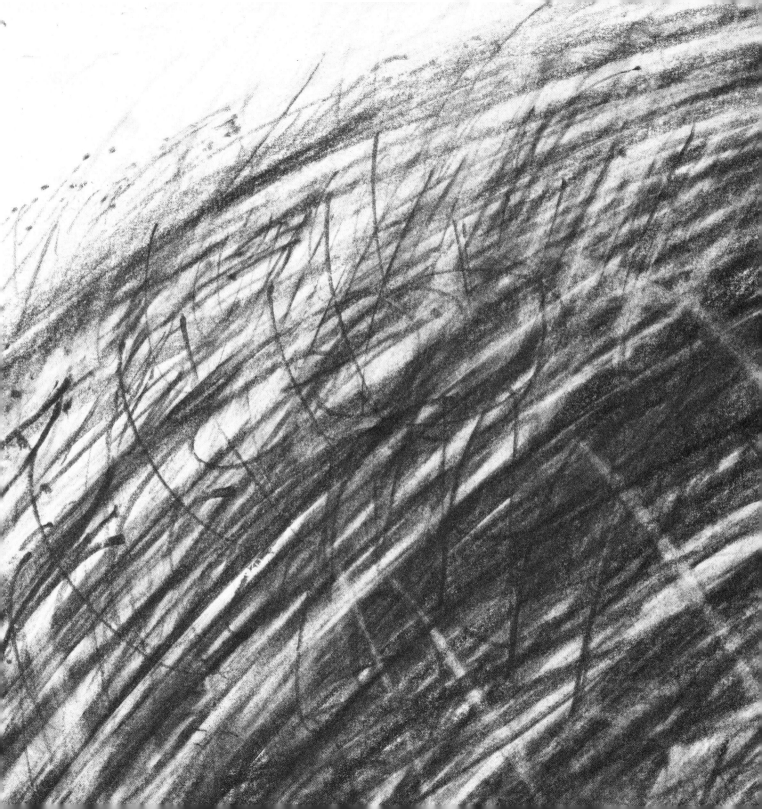

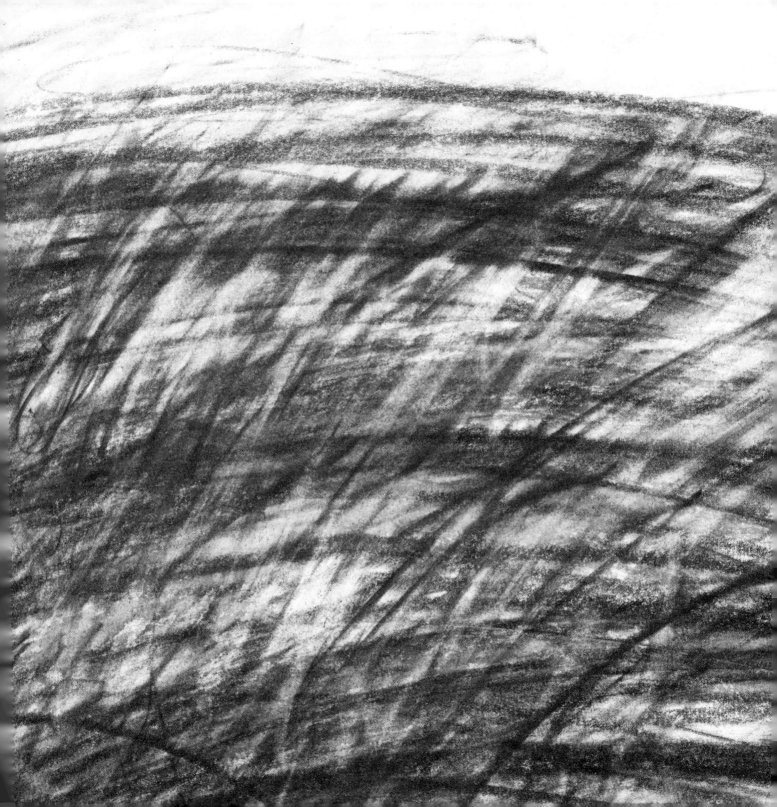

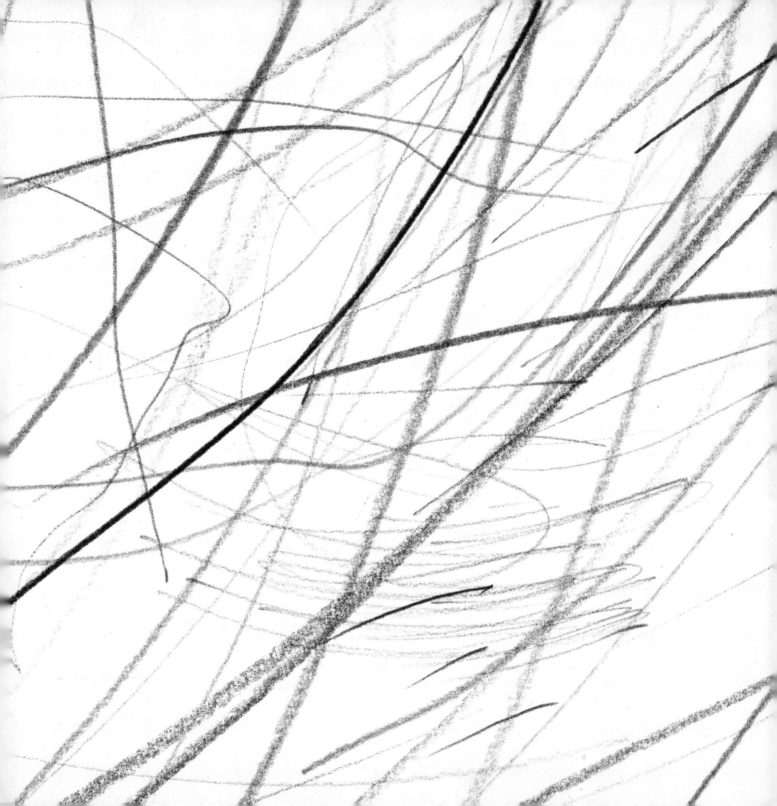

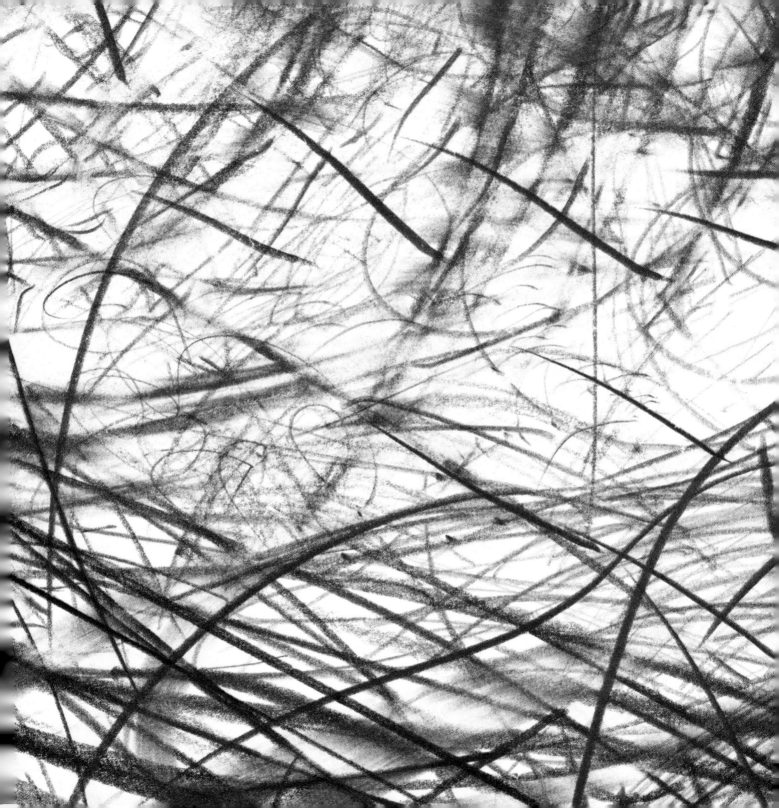

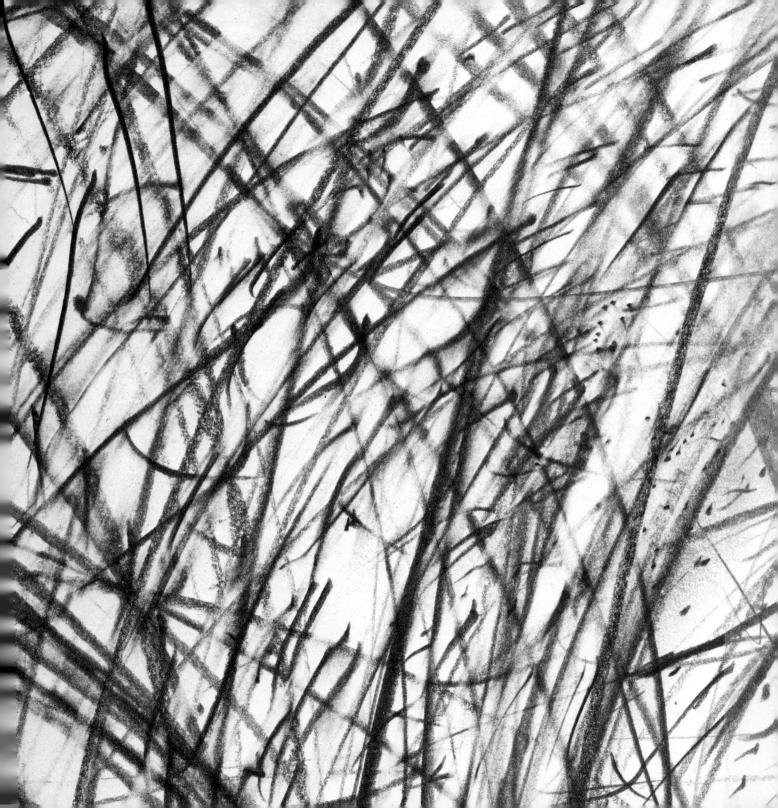

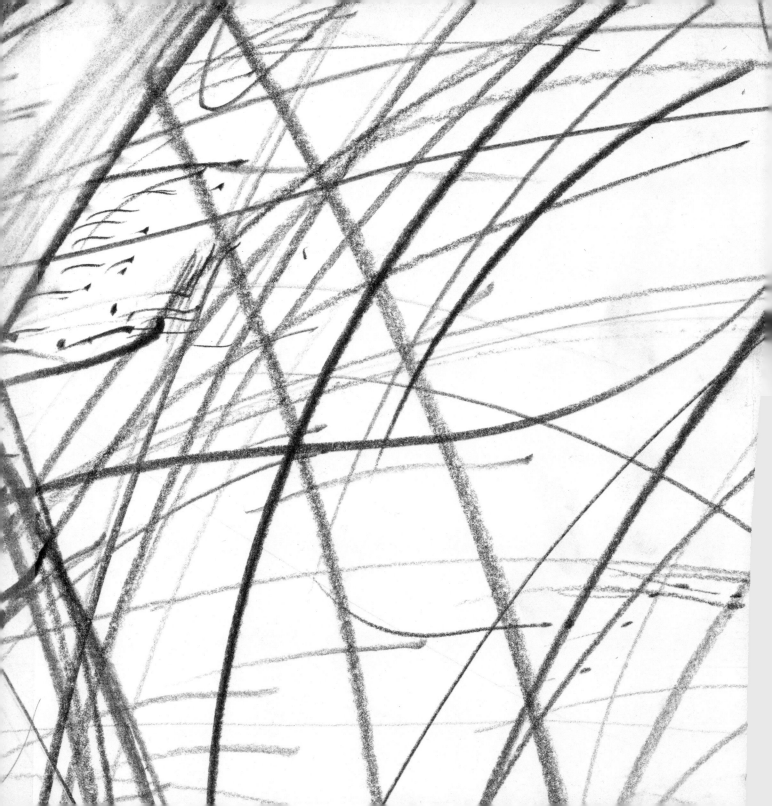

Robert Wilson

Born 1941, Waco, Texas. Attended University of Texas, 1959–62. Received B.F.A. from Pratt Institute, Brooklyn, 1965. Lives in New York.

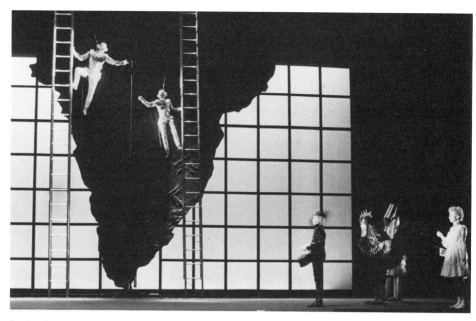

Setting for **the CIVIL warS**. 1984. Cologne. (Photograph: Günter Beer, courtesy Byrd Hoffman Foundation)

Selected Individual Exhibitions

1967 *Poles* (an outdoor environment/theater/sculpture), Loveland, Ohio **1971** Willard Gallery, New York **1974** Musée Galliera, Paris **1975** Galerie Wunsche, Bonn **1976** Iolas Gallery, New York **1977** Marian Goodman Gallery, New York **1979** Marian Goodman Gallery, New York/Galerie Rudolf Zwirner, Cologne/Paula Cooper Gallery, New York **1980** Neuberger Museum, State University of New York, Purchase/Contemporary Arts Center, Cincinnati **1982** Marian Goodman Gallery, New York/Galerie le Dessin, Paris/Galerie Annemarie Verna, Zurich/Städtische Galerie im Lenbachhaus and Galerie Fred Jahn, Munich/Franz Morat Institut, Freiburg **1983** Pavillon des Arts, Paris/Galerie Brinkman, Amsterdam/ Museum Boymans–van Beuningen, Rotterdam/Gallery Ueda, Tokyo/Castelli Feigen Corcoran, New York/Museum of Art, Rhode Island School of Design, Providence **1984** Otis Art Institute–Parsons School of Design, Los Angeles/Jones-Troyer Gallery, Washington, D.C./Kölnischer Kunstverein, Cologne/Paula Cooper Gallery, New York **1985** Institute of Contemporary Art, Boston

Selected Group Exhibitions

1974 Galleria Salvatore Ala, Milan **1975** Paula Cooper Gallery, New York **1981** *Biennial*, Whitney Museum of American Art, New York/*Other Realities*, Contemporary Arts Museum, Houston **1982** *The Next Wave Artists*, Paula Cooper Gallery, New York/*American Drawings of the Seventies*, Louisiana Museum, Humlebaek, Denmark **1983** *The Permanent Collection: Highlights and Recent Acquisitions*, Grey Art Gallery, New York University, New York/*Der Hang zum Gesamtkunstwerk*, Kunsthaus, Zurich/*Art & Dance: Images from the Modern Dialogue, 1890–1980*, Neuberger Museum, State University of New York, Purchase **1984** *An International Survey of Recent Painting and Sculpture*, The Museum of Modern Art, New York

Performances

1969 *The Life and Times of Joseph Stalin*, Brooklyn Academy of Music, New York **1976** *Einstein on the Beach*, Metropolitan Opera House, New York **1983** *the CIVIL warS: a tree is best measured when it is down*, Schouwburg Theater, Rotterdam **1984** *Einstein on the Beach*, Brooklyn Academy of Music, New York ∎

Studies for Richard Wagner's *Parsifal*. 1984. Pencil.

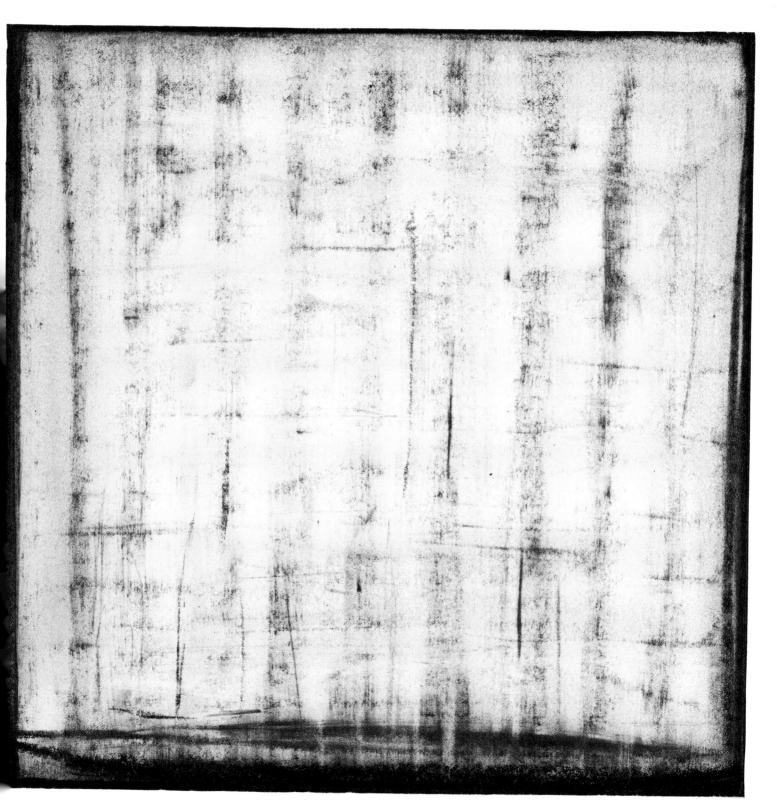

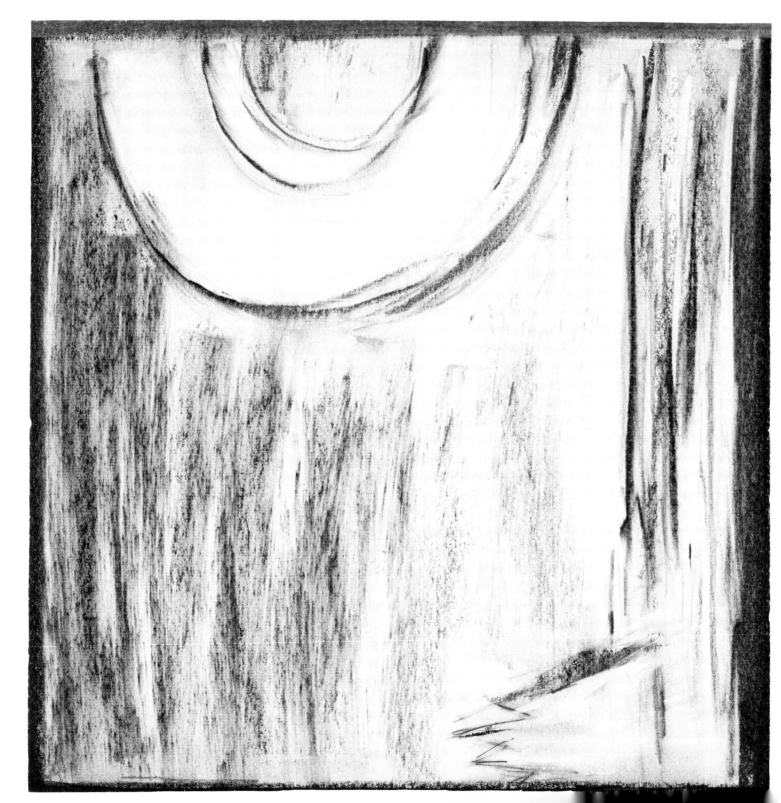

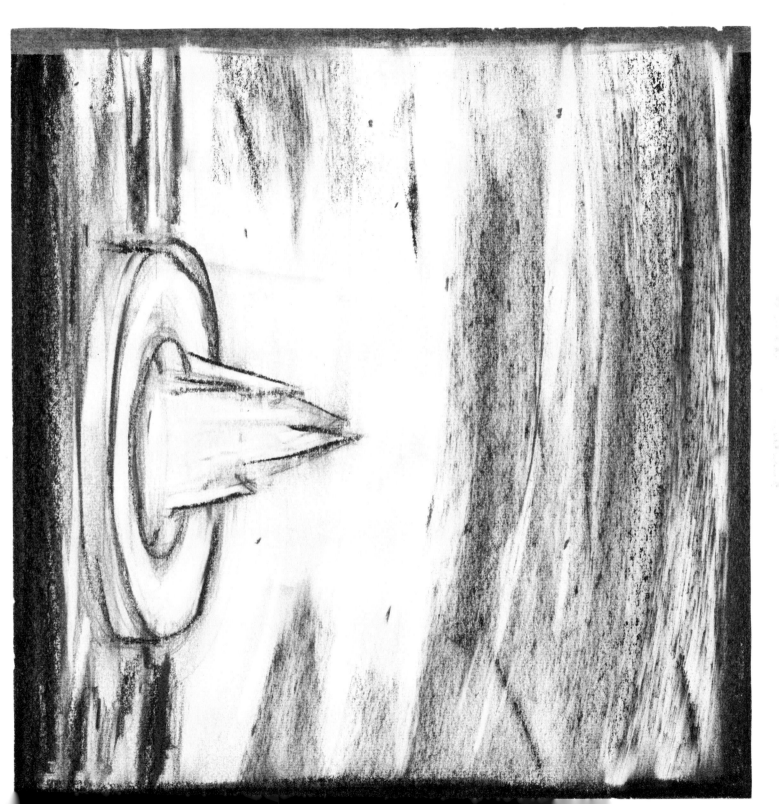

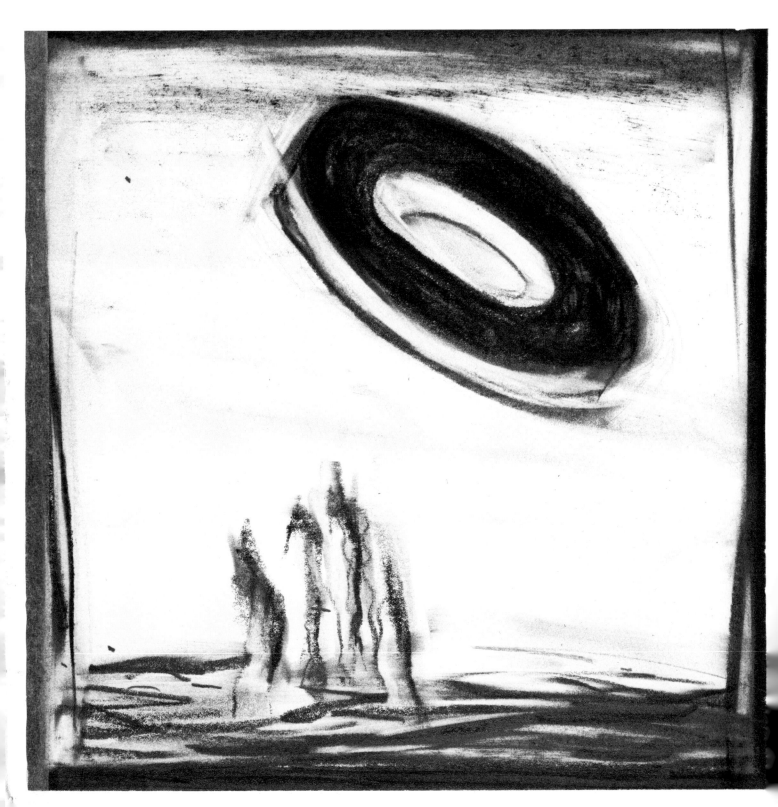

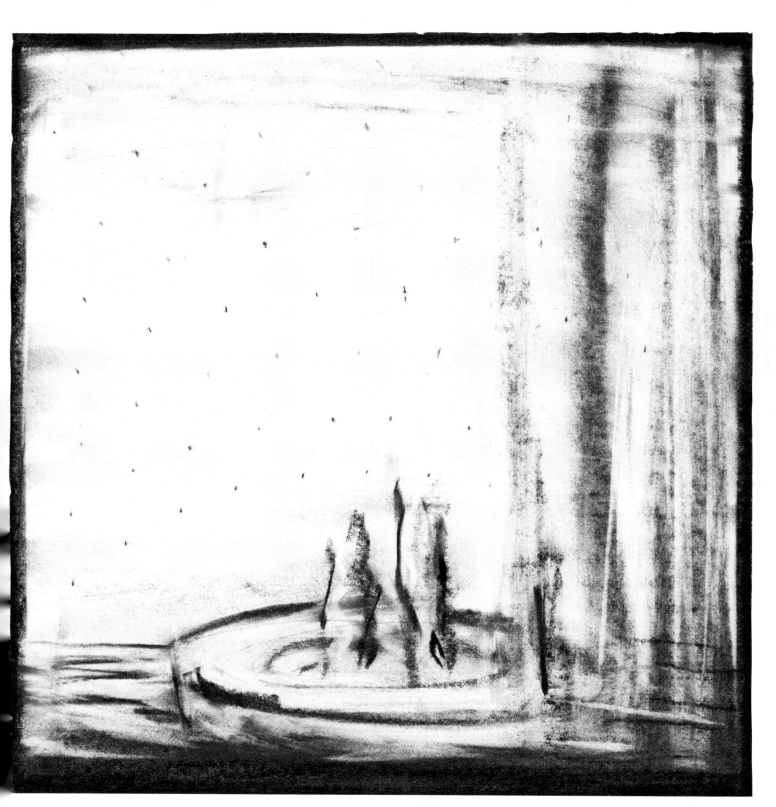

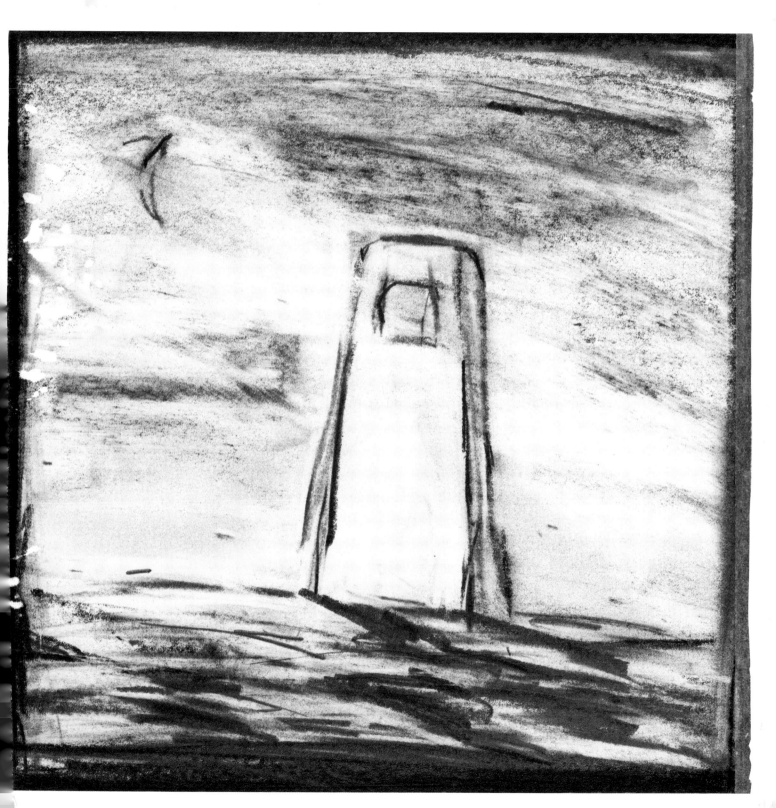